UNBECOMING

Elsie Ray

Unbecoming
Copyright © 2021 Elsie Ray
Illustrated by Elsie Ray
All rights reserved.

No part of this book may be reproduced in any manner whatsoever without the prior written permission of the publisher, except in the case of brief quotations embodied in reviews.

ISBN: 978-1-61244-967-8
LCCN: 2021902464

Halo Publishing International, LLC
8000 W Interstate 10, Suite 600
San Antonio, Texas 78230
www.halopublishing.com

Printed and bound in the United States of America

"Go out and create. If you fail,
learn from it. But don't give up,
especially before you start."

- Carl Middleton

To my innermost circle.
Y'all know who you are.

Lies I tell most frequently:

1. This is my last cigarette.

2. This is our last kiss.

I found photos of us,

Polaroids we took

in the back of my car.

I was always two places

at once when I was with you.

It was heaven in those moments,

but my body and soul

weren't designed to defy

the laws and dimensions of love.

You are worth so much more

than half my heart's beat.

So much of my mind's time
is spent thinking of "forever"
and how impossible it seems.

But maybe it's not
so far-fetched...

Being with you now
already feels as though
we are outwitting the fates.

Momma never told me
there would be days like this,
days that feel like
it's all too much
and all for nothing.

Maybe she believed
if she did her best,
I'd never have to face
days like this.

Every day,
you taught me
what not to become.

And even still,

I have to fight
not to become it.

Could it end in bitter remorse?
Perhaps.
Will we walk away,
heads and hearts held high?
Perhaps not.
But it's always worth
the chance
to feel so intensely alive...
Always.

I took out a loan
against the night sky.
I wished upon
every star I could see,
even the stars that
hadn't fallen yet.
So maybe when one falls,
my wish will come true,
and I'll have a chance
at forever with you.

You don't always

have to create
from scratch.
Allow yourself
to be inspired

by what is already
in front of you.

I wish
 you were
 getting high with me
and losing your grown-up side.

confidence

is

simply

lack

of

comparison

On life and blanket forts:

Stop thinking too hard.
Just do
and create.
Trial and error must be
your only guide.
And if you're tempted
to give up, don't.
You'll be so proud
when it's finished.

Be here.
Now.
As you
are.
It is good.
It is enough.
It is worthy.
And, baby,
it is beautiful.

Some days, I need music,
some days a view.

Some days, I need adventure,
but every day, I need you.

Is it so evil

to prefer desire

over tolerance?

It was never respect
you were seeking,
but obedience.

It was never love
I was seeking,
but freedom.

When you left,
I nearly drowned.
I floated naked
and vulnerable
in an ocean of people
who could do nothing about
the deep blue waves
engulfing my mind.
When you left,
I had to save myself.
Thank you.

The Sun
and the Moon
only share their light
with us
sometimes.
It's just as well
if your light
doesn't always shine.
providing warmth
and visibility
at all times,
at all costs,
was never your weight
to carry.
The Sun
and the Moon
shine as they please,
as they can,

and the world adjusts.

When I die,

I'll be damned
if the wrinkles I got
from smiling
aren't the deepest
creases in my face.

If you can feel it,

it's important,

and you MUST listen

and protect it.

The things they hate
about you
are most likely things
you learned in order
to survive them.

where clothes end
and sunrises begin,

meet me there
tonight.

You were my religion,

and I was the only

reason you ever needed

Jesus.

If it's not good

and it's not getting better,

then what in the actual fuck

are you still doing there?

Maybe it's not about you.
Maybe the pain you feel
isn't their responsibility.
Maybe their decision
wasn't made to spite you.
Maybe it had nothing
to do with you
and everything to do
with them.
Maybe YOUR expectation
didn't align with the reality
of what they wanted.

Every crossed boundary,

I endure.

Against all counsel,

I stay.

How did I become

the villain?

Can't you see?

There would be no need

for these walls

if I didn't need

to protect myself

from you.

We do the devil's work

by making this life hell

for those who sin differently

than ourselves.

We're just as evil

as the evil we hate.

I was ready,

but you were just lonely.

I wish I had known.

You're being called
from this winter's sleep.

Emerge slowly, child.
Take time for yourself.

Pause for rest
between each movement
if need be.

Be present.
Be patient.

The sun is still
warming the earth

in preparation for your feet.

Find grace for yourself,

gratitude for life,

and love for all that has
kept you safe.

'Are you sure?'

Her first instinct

was to think.

until there was nothing left

to think about on the matter.

So whether she was

inviting you in

or letting you go,

You knew for damn sure

she'd thought about it.

The pain of staying stuck is far more agonizing than the pain that comes from change and growth.

Your happiness cannot be subjective.
You must insist on happiness despite everything else.

I am everything

I will ever be

and ever was.

I am so very alive.

And I rage onward.

There's no time

to look back.

Think presently.

Feel retrospectively.

Focus on your breath.
One breath at a time...
One
after
another
is far more manageable
than trying to anticipate
how many more moments of infinity
until you're okay.

As far as soulmates are concerned, the only people meant to be together are liars and fools.

Cat naps, & eating pizza
in bed with you
without pants,
because there was just
no need for them.
Our lazy Sundays remind me
that I don't have to
exhaust myself
for time to have been
well spent.

A safe box is a box nonetheless.
The whole point of it all is to

GET
OUT
OF
THE
GODDAMNED
BOX.

I felt the moment
you let yourself detach.

I felt it in my skin,
my chest,
my stomach.

I felt it every moment after.
When I looked in your eyes, I saw
a stranger.

Despite my awareness,
I wasn't broken
completely.

But when you said it out loud,
the words took up the whole room
and left no space for me to breathe.

It became real,
and I could no longer convince myself
I was crazy for thinking it.

The fairytale is
being cared for in your lowest hour.
The fairytale is
still being seen even when
the light no longer resides within you.

The fairytale was never
a loud, boastful
production.
It wasn't a grand gesture.

The fairytale is
a quiet, genuine embrace
unbeknownst to the rest of the world.

Pay very close attention
to how they react
to things they don't understand.

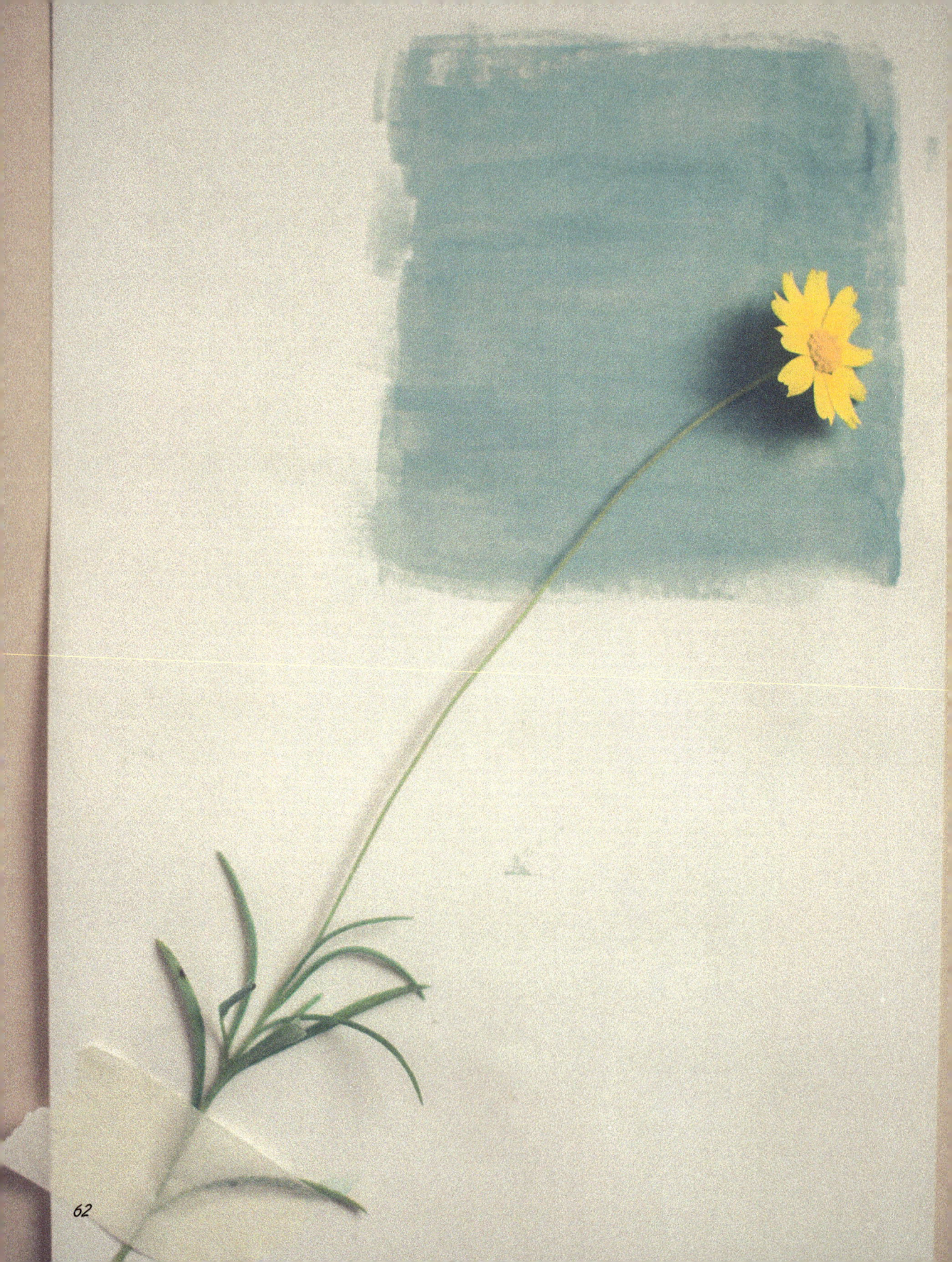

I needed a break
from all the times
you said you needed
a break from me.

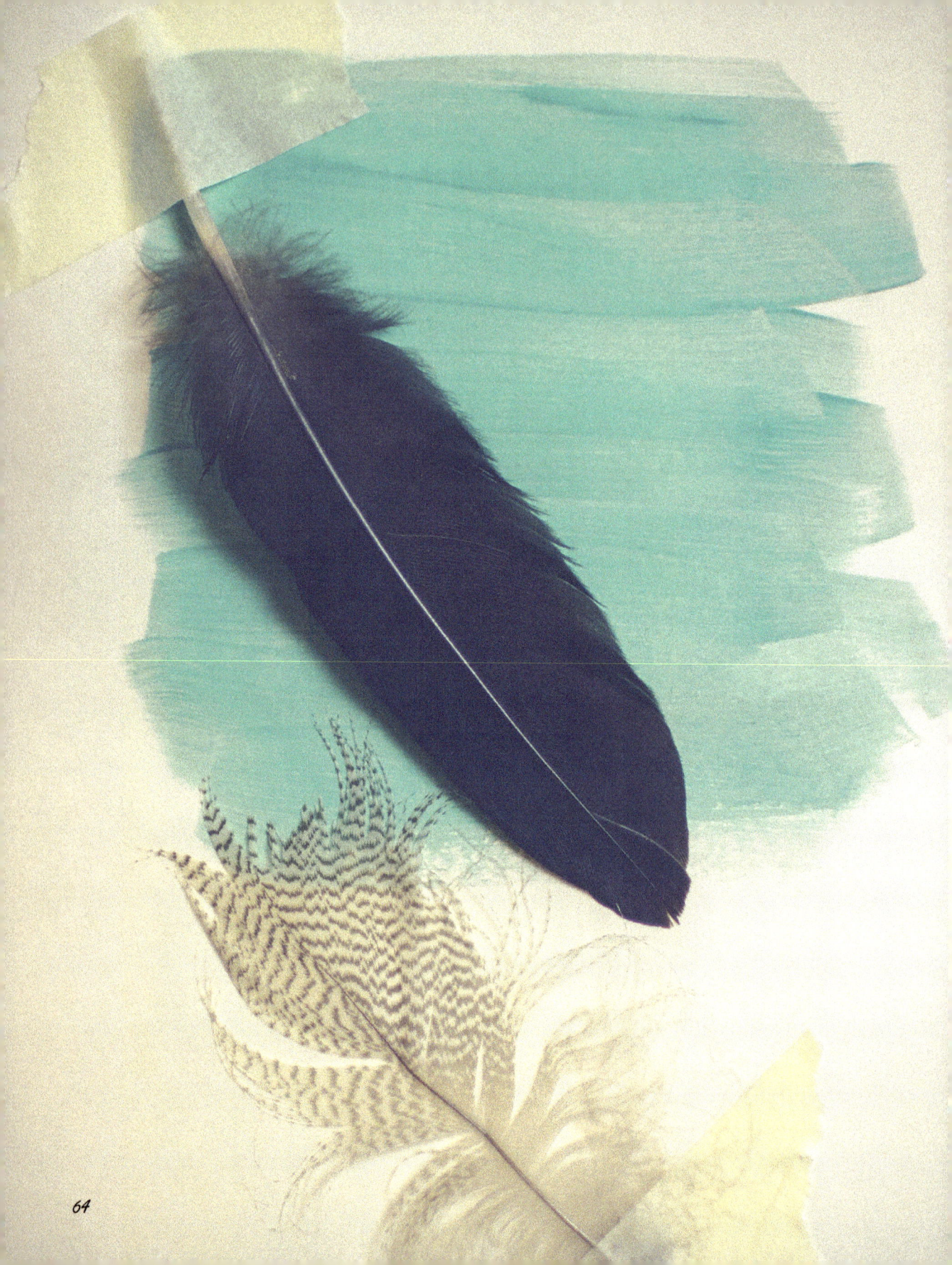

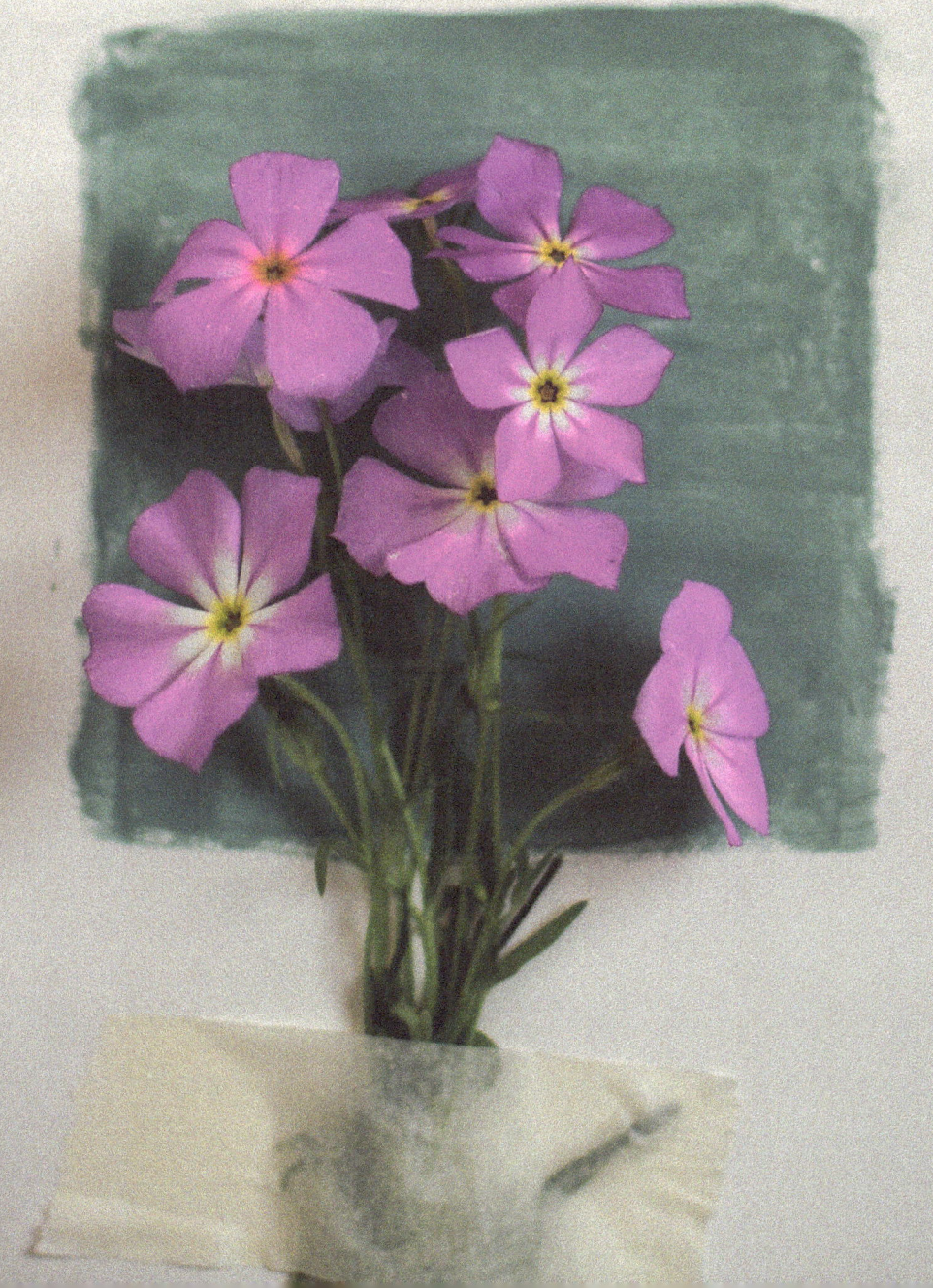

Do the truly (un)selfish work of finding your own happiness.

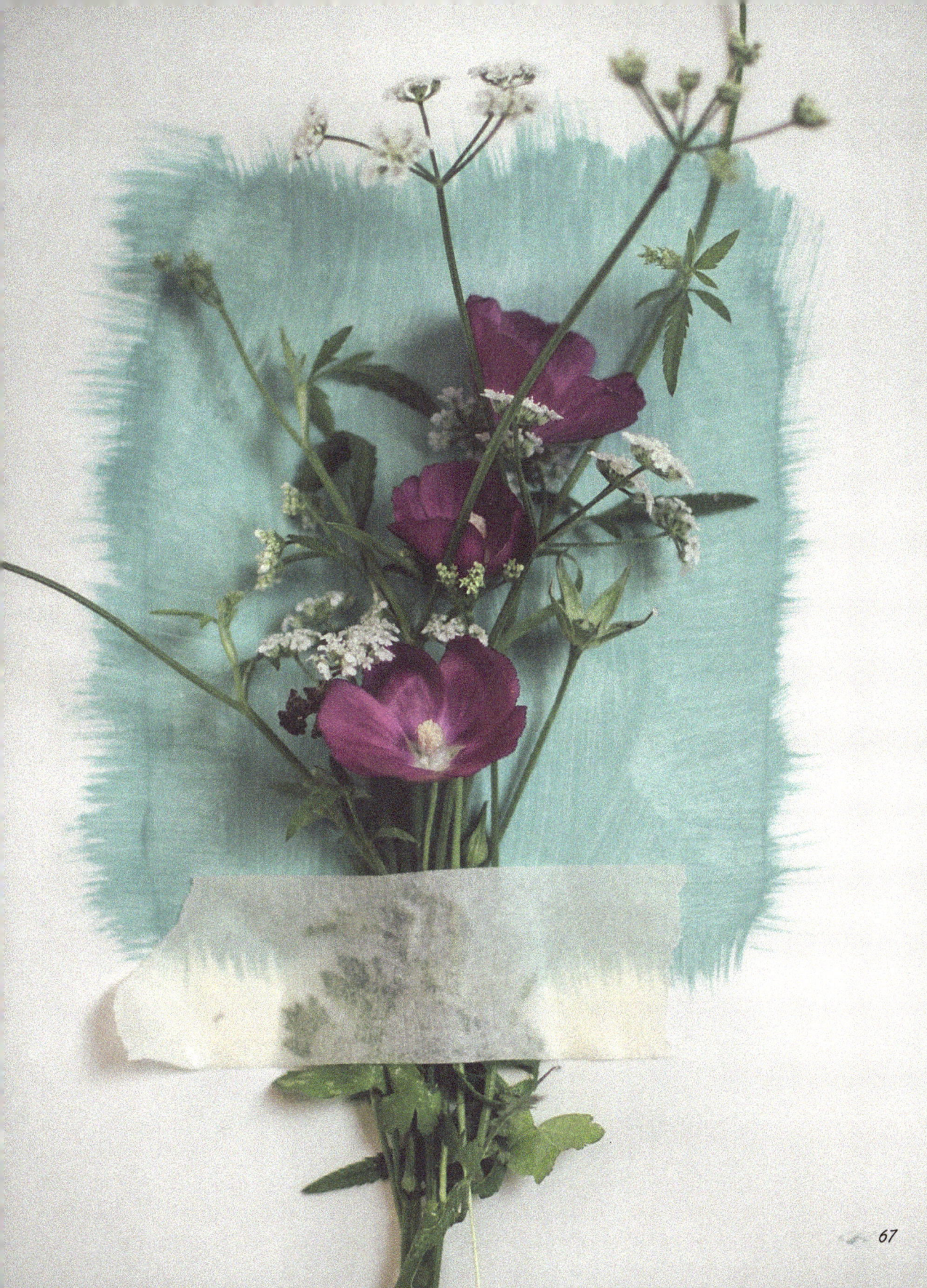

In his dark & guarded heart
is a light that saves.
He protests against the demons telling us,
"Death is but freedom."
I know a hero.
I am living proof.

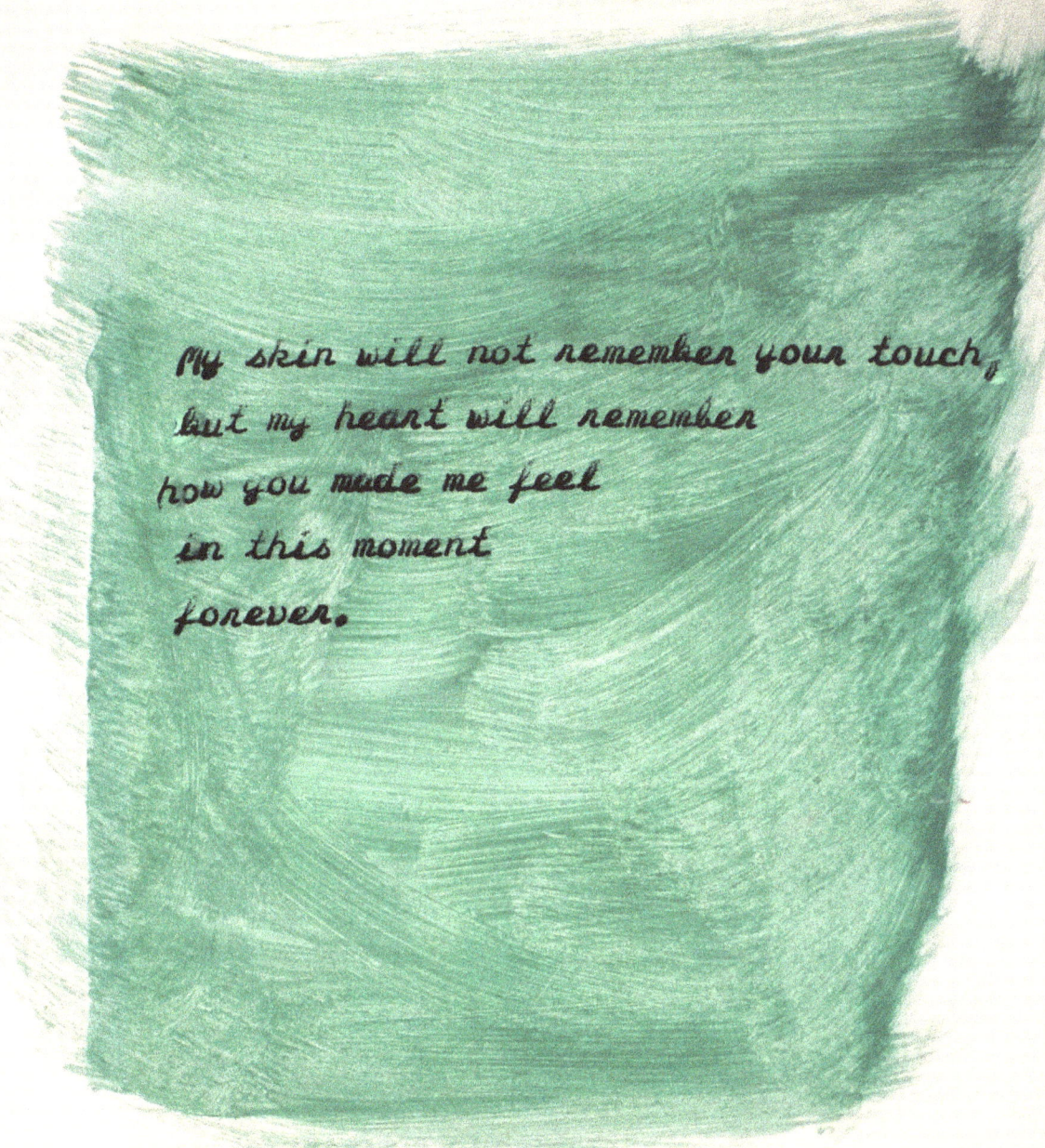

my skin will not remember your touch,
but my heart will remember
how you made me feel
in this moment
forever.

This moment is temporary.
The hopelessness won't last.
You will find joy in new things.
When all is well,
when everything feels perfect,
remain humble.
When all seems lost,
when it's all too much,
remain at peace.
It's only a season,
and the pendulum will continue
to swing.

My good intentions
have been at war
with the broken parts of me
for far too long.

 I am so tired.

Unapologetic authenticity
will cleanse your life
of all things (and people)
not meant to be there.

How are you to know
what you like
until you try it?
How are you to know
where you belong
until you've been?

Freedom from our fragility
is the furious & humbling
pursuit of & demand for
equality & justice
for ALL.
Keep saying their names.

In you,

I found a love

I no longer believed existed.

If it's the emotional equivalent of lighting yourself on fire, don't fucking do it.

Always remember his calm,
stable love.
Remember how he taught
you to trust again,
and remember the time and care
he put into showing you
what love should have
looked like
all along.

Love is

wanting them to be happy,

without conditions.

Love is an intentional,

conscious decision

to embrace & encourage,

to make space for all

that they are,

even the parts of them

that don't serve you.

Access denied...

Only grant them
the access they deserve.
If they tug at the inches
you give them
until they are stretched
into miles,
count your losses.
Next time,
protect and preserve
with boundaries.

I used to carry you with me.
I grew tired, for you were too heavy.
Our memories,
a dead weight,
no longer made me proud.
I grew weary.
I had to set you down.
I had to set it all down.
And I sat with it for a while,
fighting with myself,
trying to determine the worth
of picking it all back up
to carry on carrying.
I knew it would have been impossible,
yet I still struggled to leave it behind.
So I stayed.
And I mourned
until I was ready,
until I grew angry at myself
for all the time I'd wasted.
You left me a long time ago.
Today,
I finally left you.

Today, I saw your name
on a beautiful girl's chain.
I thought maybe I'd get one
in honor of my new lover,
but something tells me
it wouldn't wear
quite the same.

92

The only way to remain happy is by finding peace in uncertainty.

You are called to live
beyond the mercy
of their gaze.

Be fulfilled
by the parts of yourself
that you actually
had a hand in creating.

The love I had for you
far surpassed
the respect I had
for myself.
You taught me the most
valuable lesson.

It's up to you

how long you spend

accepting their excuses

when you should be

accepting their apologies.

My pure addiction,

disguised as sobriety.

I'll lie

to you,

to all who care for me,

to myself,

to God.

I'll say it's over,

and I'll say it

over and over again.

It's not love.

It's ecstacy

and mental anguish.

But anything less

than this beautiful hell

wouldn't feel like love at all.

Nothing hits quite like you,

my drug of choice.

We are all products of
rejection
heartbreak
compromise
and settling.

Living is easy.

Surviving is hard.

Growth is harder.

Don't give up.

You are so close
to being proud of yourself.

Take lovers the same way

you take vacations,

with piqued curiosity

and loose expectations.

Have a new and unique encounter

each time,

until you find

what feels like home.

So determined to feel
better.
So desperate for it all
to be over.

A constant teeter
between
hope & surrender.

It's going to hurt

no matter what.

So do what you know is right.

As sure as morning comes,
even after the longest
and darkest night,
 you will find the strength
to shine again.

The way you throw around
"miscommunication" as an excuse
every time you fuck up
just makes me think
you don't know what that word
means.

I practiced what I thought
it would look like
to not hurt.
I've gotten quite good at it.

As it were,
practice made perfect.
And now,
I celebrate your absence
and bloom in solitude.

How far is it between

yes & no,

between

yes & maybe,

between

maybe & no?

finally,

I am able to prioritize

my peace

over

your acceptance.

While you continue

to make it known

that your approval

was never attainable,

please know

it was also never required.

Wake up.
Brush your teeth.
Read of the world's injustice.
Feel everything so deeply,
until you can no longer feel.
Zombie through the rest of
the day.
Stare at the ceiling fan.
Let your thoughts drain
any remaining energy.
Fall asleep (maybe).
Repeat.

 This is survival.

If you love her,

please remember,

her shape will not be held

in the shape of your expectations.

She is magic.

And she won't be contained.

The silhouette of your face
at first light.

Your sleepy,
watery eyes,
like bourbon on the rocks.

The peace and sureness
you exhale with every
wave of breath.

For these things,
I became a morning person.

It's only human

to consider

setting it all on fire

for a chance to start

over again.

We think,

More intentional steps

this time.

But a different path

only guarantees

different challenges

& opportunities for

new mistakes.

To live mildly
is the ultimate act
of blasphemy.
To reject and avoid
before considering or
experiencing for oneself
is a great disrespect
to any god.

Stop moving in directions
meant to keep you lost.
Go a new way,
at a new pace,
until you get stuck.
Then rest,
recover,
repeat.

Feeling said,
"You claim that I'm
the irrational one,
but I'm only trying
to help you understand.
You rarely grant yourself
permission to hear me out,
using convenience as your
argument.
But one could argue that
your avoidance is far more
irrational
than my awareness and concern.
You think that I'm nagging,
but you're the one who
refuses to let it go.
I never wish to be a burden,
but I have nowhere to go,
and I will continue to swell
until you listen.

You decide how long we suffer."

Lexapro Week 1:

This is,
 no matter what "this" is,
either going to be
a triumph
or just one more part
of your survival story.

Some things are supposed to hurt
forever.
When you forget the pain,

you risk repeating
mistakes.

Let it hurt.

The pain will keep you alive.

Compromise is easier to come by
when each party can say,
"This life is yours
as much as it is mine."

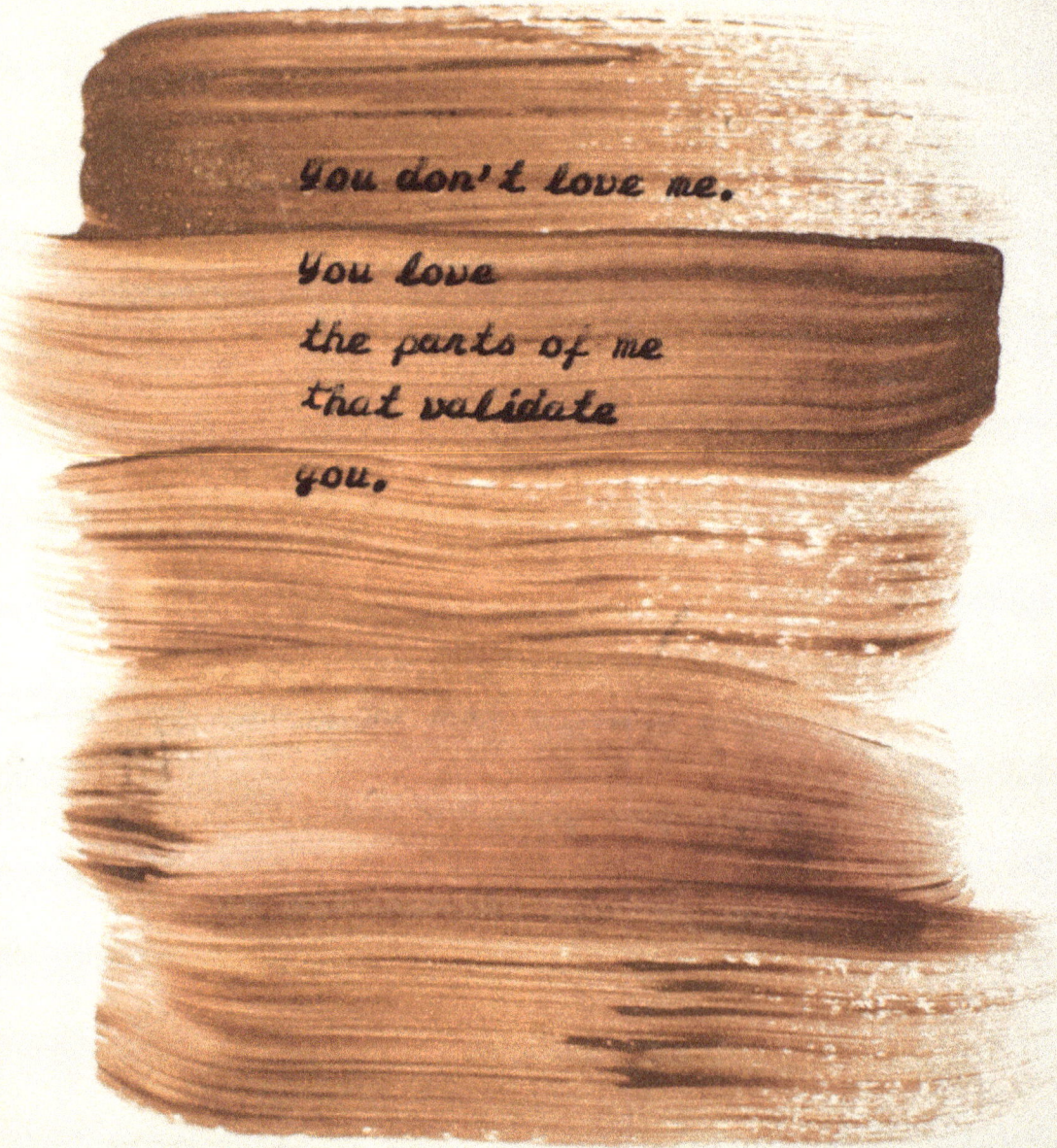

You don't love me.

You love
the parts of me
that validate
you.

It was wild,
and when it was over,
it hurt
so much
for so long.
But goddamnit,
if that wasn't love...

You told everyone
I was crazy
and left out
your role in it
for a more
convenient truth.

Unfortunately for both of us,

life was only possible

apart.

You are not failing.

You are still here.

Each moment you're alive

is a victory.

Every breath

is a success.

This moment,

NOW,

is the only thing that ever truly matters.

Sometimes it's better
to love
and be loved
from a distance.

Sometimes it's better
to be admired
without the threat
of being consumed.

The words hang,

unmoving, between us.

I sometimes wonder

why anyone ever talks at all.

We never fucking say

anything useful.

How much of ourselves
is wasted on those
who do not seek camaraderie,
but our inability to say,
"No"?

Treat their love
like a balloon on a string.
Pay close and precious attention,
or you will be left
to watch helplessly
as it floats slowly,
and all at once,
away forever.

The only thing more empowering
than learning to unlove you

was finally learning
how to love myself.

If my thorns
are too sharp
for you to hold,
please don't pick me.
Save us both the pain.

Let the disconnect happen.
Allow things to fade away.

Just because you recognize a growing distance,
it does not mean it is your responsibility

to bridge it.

Talk to me.
Vent to me.
Pull out your feelings
one by one
and hand them to me.
Let's get down to
all the things
you've been too afraid to say.
I can handle it.
I promise we will be okay.
Don't let our love suffocate
in this haze of silence.

Silence is the surrender to indifference.

www.ingramcontent.com/pod-product-compliance
Lightning Source LLC
Chambersburg PA
CBHW041919180526
45172CB00013B/1334